D0197004

Traveling Light

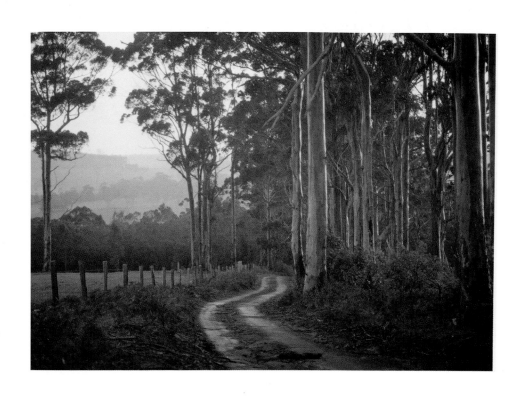

Traveling Light

Chasing an Illuminated Life

Deborah DeWit Marchant

William, James & Company
Wilsonville, Oregon

Copyright © 2006 by Deborah DeWit Marchant
Photographs Copyright © 2006 by Deborah DeWit Marchant
All rights reserved
Printed in China

No part of this book may be reproduced without written permission
from the publisher, except in the case of brief quotations
embodied in critical articles and reviews.

Cover Photo: *Kirsty's Drive* by Deborah DeWit Marchant
Author Photo: Owen Carey
Design: Phil Kovacevich/Kovacevich Design

1 3 5 7 9 8 6 4 2

Library of Congress Cataloging-in Publication Data
available from the publisher

This book was originally published as *Traveling Light: A Photographer's
Journey* by Impassio Press, Seattle. This edition is published by
arrangement with the author. All rights reserved.

ISBN: 1-59028-149-7

William, James & Co.
an imprint of Franklin, Beedle & Associates, Inc.
8536 SW St. Helens Drive, Ste. D
Wilsonville, Oregon 97070
www.wmjasco.com

Contents

Acknowledgments

An artist, in whatever discipline, can never thank enough people. We live and work by the grace of those who understand better than ourselves that what we do is an integral part of society.

I've experienced the generosity of many people along the way. Some of these people may not remember me, but they were there and I remember them as important contributors to my life as a photographer and an artist. I am grateful to all the people who housed and fed me, encouraged me, unguardedly taught me, exhibited or purchased my work, and who gave me immeasurable sustenance by responding to my images.

I also want to thank Erika Berg and Olivia Dresher, two passionate and intelligent women whose separate but faithful commitment to my work gave me the courage to begin the book and then the confidence to complete it.

My family has always been my greatest support. I thank my mother, my father, and my brother Michael for their unselfish and unfailing encouragement of my dreams and for their tolerance of my single-minded purpose.

And I want to thank my husband, Bob, who cannot be separated from anything I attempt or achieve or hope for. He is there in everything I am.

Introduction

Inside these covers one could find several different books. A photographic essay. An autobiography. A story about an artist's creative process. In fact, while working on this book, there were times when I felt it flutter beneath my hands with its own living breath and lead me in scattered directions of its own.

But there is a constant throughout the story and the pictures. A beacon that not only directed the contents of the book but ultimately became the subject as well. Light. Its power and its mystery. Those qualities that help us understand what we see.

As a photographer, I've spent most of my life gathering images. It has been said that light is the photographer's paintbrush, and so I studied it with the earnestness of a da Vinci pupil. After twenty-odd years of capturing light on film, I one day discovered that in my filing cabinets (in the form of negatives) and on my bookshelves (in voluminous personal journals) lay the particles of my life, having gathered substance as time went by. Together they made a chronicle of not only the places I'd seen but also the effect they had had on me.

Photographs are unadulterated evidence of the visual choices we make. I was lucky to have them, like bread crumbs to follow and retrace my path. I couldn't deny their truthfulness, and it was uncanny how certain kinds of imagery pervaded certain periods of my life.

As I leafed through old writings and photo contact sheets, I gazed down in wonder at the mysterious sense they made. A pattern emerged. A true story held together and described by light-defined moments assembled out of the motes twinkling in a shaft of recognition. My single-minded quest to explain

light had led to the unexpected proposition that the understanding we search for materializes out of just living and believing our very own eyes.

I might not have wished to share these personal discoveries had I not had the belief that other people have similar experiences. Exhibiting my photographs over the years, I have watched people's reactions to images that I often thought had meaning only to me because I had been witness to the moment in real time when the picture was taken. But I learned that everyone brings a personal past to their sight, projecting themselves into an image in order to receive back something he or she can relate to personally. This has confirmed for me the universality of life's experiences, and the possibility that a moment in "real time" is often just a comprehendible moment in eternity.

Since the experience of writing this book, I look back and trace the thread of beauty that runs through my life. It is there. Constantly. It is what I have always followed, reaching out, sometimes in the dark, even when I didn't know it. It is the part of me that makes sense.

Traveling Light

When the Light Rose from the Earth

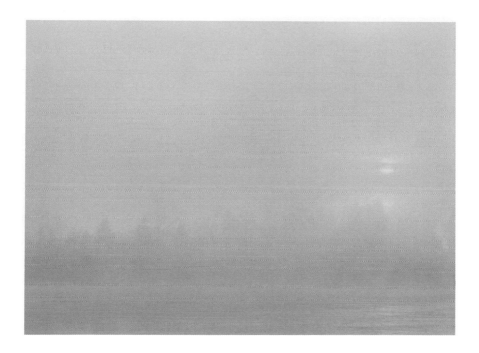

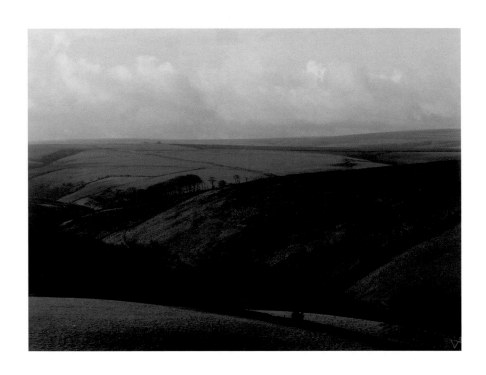

When I was fifteen years old, my mother took me to visit my grandmother in London. What made this particular trip especially memorable was that just before we drove away from our small, white, dormered house outside New York City, my father handed me his little 35mm viewfinder camera. I was honored by his trust in me and happily accepted the gift.

As in the past, we stayed in my grandmother's third-floor flat near Hyde Park. But during this visit we also took the train north through the autumn-colored countryside to visit old family friends on an Aberdeenshire farm. My father, Dutch by birth, and my mother, British-Dutch, had maintained strong European ties, and we had family and friends scattered across the British Isles and Holland.

During the days we spent with our Scottish friends, they showed us the local sights. We drove over the tweed-colored highlands and through stream-sliced valleys, the scenery spread before us.

So near the sky, astride those naked hills, something happened to me.

I can remember breathlessly contorting myself in the back of the car, the unfamiliar camera in my hands, trying to record, through the rear window, the movement of those cloud-bound moors as we sped by them. Each click, seconds after the one before it, captured a distinct and new moment but with such competent subtlety that when I got the film back after our return home, there was nothing but an envelope filled with dozens of pictures of the seemingly same drab hill and uninspiring sky.

The Life that had animated that spare, clean landscape was hidden somewhere between my memory and the pictures I held in my hand. I was disappointed and puzzled by the profusion of murky horizons above brown landscapes so purposefully captured on my film. Each moment had been different and my naïve eyes had sensed the changing light. But I didn't understand the light's significance, its subtle qualities, or how to capture it. I only knew that traveling light made my pulse quicken.

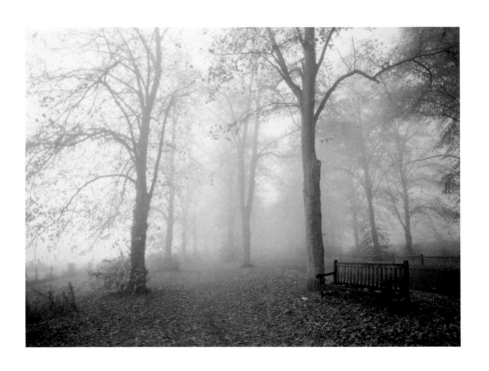

Over the next couple of years I continued to take photographs on walks through the neighborhoods of our town. I would wander to the beach on bitter, wintry days or sneak onto the deserted local golf course at dawn.

I would take pictures of what I saw. I set up a makeshift darkroom in our kitchen, and after the family had gone to bed, I would print my black and white negatives. Until three or four in the morning I worked in the fumey, cluttered, cardboard-blackened room. In the darkness my pictures appeared on sunken blank surfaces, while I stirred the bath of chemicals like a witch's brew.

Captivated, bathed in the orange flush of the safelight, I would recall the split-second exposure and then watch it emerge, transformed into a new picture, now a complete photograph framed by four clean white edges.

Despite this fascination, I never seriously considered a future in photography. I finished high school and went on to college. It was neither a happy nor successful effort, and after two years, with a stride of youthful confidence, I abandoned an intended degree in agriculture. Shortly thereafter, I sat once again in a train headed north from London with a new camera (a large, serious one purchased with the money made from the sales of my first photographs) by my side. This time a glistening spring streaked by the window.

The separate, rectangular world I saw through a viewfinder had continued to intrigue me throughout my confused college years. Now I was on my way to work on our friends' Aberdeenshire farm and to capture my experience on film.

As the train approached the Scottish border, I pressed my nose against the windowpane. My body was electric with the anticipation that accompanies youth, a time when each sensation is a momentous, sparking discovery. The long, late light that hovered over the North in those middle months of the year seemed to grow in unearthly waves out of the very land it lit.

The rails rhythmically clicked beneath the train compartment seat, while the light enveloped and caressed me as it throbbed across the dusky expanses of the maroon hills and midnight valleys. My thoughts descended deeply into the light. Once again my pulse, like a thousand bouncing marbles, filled my ears, my veins, my heart, until I thought I would burst.

I would come to have this experience many times in the presence of light, and relief came only when I took a photograph.

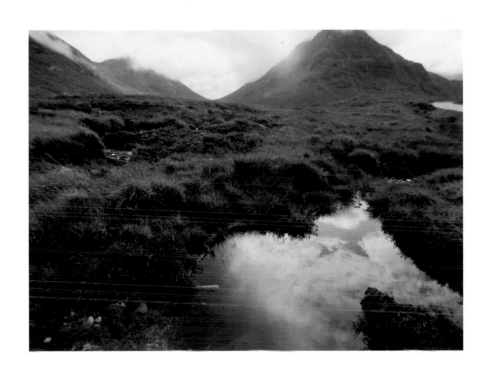

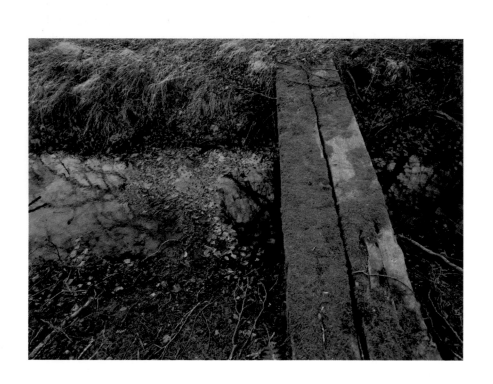

My time on the farm in Aberdeenshire allowed my young spirit to grow up out of the earth and meet the world. The presence of thick, abundant Nature provided me with countless physical experiences that sharpened my awareness and offered kinship with all things existing in that light that fascinated me. I gulped it down like champagne at a coming-out party where I was the debutante and everyone had gathered under the sky so I could be introduced to them. My passion was invincible. The more senses I engaged, the more my gut reacted and took my breath away, the more alive I felt.

I worked in the fields, herding large black and white cows from grazed pastures to those that were taller, greener, and juicier. We tramped over soft earth together, rubbing hide to shoulder, shuffling in the early morning mist and in the eerie half-light of a midsummer's evening. When the cows were stubborn, which was often, I chased them, running through green-grey rain, panting in air thick with water. My boots didn't strike the ground as much as sink into and suck out of muddy hoofprint holes. Finally the gathering of beasts would relent and a streaming jigsaw puzzle of cows would jostle into an old, earth-scented stone byre. Steam rose from their hot wet skins, like mist on the surface of a warm river, and it mingled with their bellows, filling the shadowy rafters above our heads until our hearts slowed to a collective beat.

Another of my tasks was driving the tractor. I was thrilled by that machine. It was huge and indestructible, yet under my total command. My ability to handle it mimicked a youthful belief that my grasp on the world was growing stronger. I planted a field of seeds with that tractor. The field sprouted turnip plants—and weeds—and later I hoed its rows for many tedious, aching days in all kinds of weather.

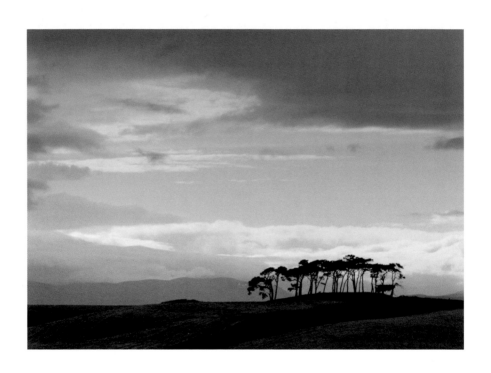

Bending over in a field for hours transformed the tiniest observation into a blessing. A winging bird or a ray of sun flaming a stand of trees was enough to make my heart clench and release with the beauty. As I cut hay on a dry and windy day, the clouds swept across the sky and turned the yellow fields into moving checkerboards of light and shadow. The same seagulls that had wobbled behind my tractor eating worms when I had plowed earlier in the season now dove headfirst into the newly-cut swaths, scooping up insects and carrying them away on the wind.

Racing against darkening clouds on the horizon, I watched over my shoulder as rows of tall grass, like ochre strands of hair, fell rhythmically to the blades of the cutter. When the engine of the tractor was shut off, a great silence fell, like sound sucked away into the ground. Moments of heavy, pounding quiet passed as dark circles on the dusty metal of the tractor defined the raindrops leading the approaching storm. I heard the seagulls cry and then the hiss of the rain that advanced across the flattened field at the end of a swift day.

Days later, rectangular cubes of hay stood out against the blazing white field like black spots before a dizzy man's eyes. Gathering the bales, joined by fellowworkers, my palms were etched by the hard baling twine, and my skin tickled with the caterpillar crawl of dusty sweat beneath my shirt. Hour after hour, lifting and heaving as the sun beat down, we then stacked those bales in a cool grey stone barn where shafts of celadon light came down through sparkling dust.

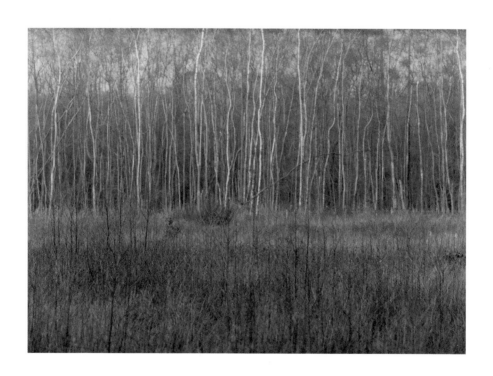

Each day was filled with sensation. Like an infant mesmerized by her own toes, I was enchanted with the natural world around me. Every physical experience branded its corresponding visual impression onto my sight.

Strawberries picked at dawn were sweet and syrupy, wet with dew, and so, so red against the black dampened earth.

Pewter-barked beech trees cast green slippery light beneath them as the rain spattered and splashed through their leaves.

Delicate woods of silver birch smelled musty, spicy, dusty, and the little trees themselves glowed like twisted strands of precious metal in the setting sun.

The cows, awkward and weighty, congregated in deep blue shade on a warm day, breathing their huge damp breaths of life.

The visual moment was heightened by the physical rawness that accompanied it. From the ancient ground and intense sensuality of this farm an awareness was born in me. These experiences were elemental, even primeval, devised by the eternal land and sky to unite me with all who had walked these fields and tramped these woods during the past thousand years and the millennia before that.

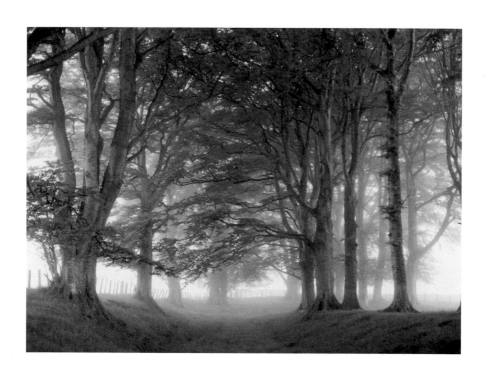

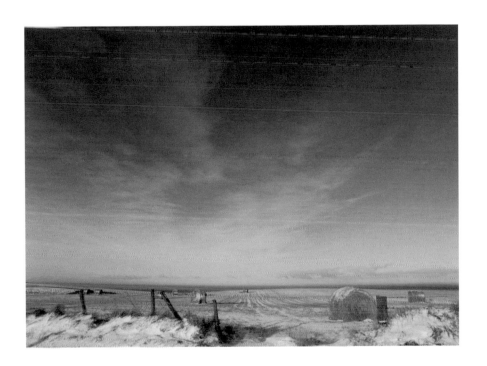

From time to time I ventured away from the farm. I thought if there was so much within this small space on the map, surely there must be far more outside it.

I traveled farther north, where the land lay undulating beneath heather and gorse and it met the sea with plunging cliffs under a huge cloud-churned sky. I spent the night on the edge of a bluff at the northernmost point of Great Britain, with only a pup tent for protection and puffins for companionship.

Not by design but perhaps by fate, it was Mid-Summer's Night. I lay on my stomach, legs in the tent, elbows as close to the edge of the cliff as I dared. I was anchored to this final edge of land, torn by the desire to free myself from the bonds of earth and the hunger to feel the sensuous grip of those very same bonds. I watched the sea and sky glimmer and fade, wink and trade light back and forth until it was impossible to tell whether the night was pale or the dawn was dark. Here was unending, ever-changing light. At the end of the earth I gazed out upon a never darkening horizon.

At that moment the sky became my source and the earth my guide.

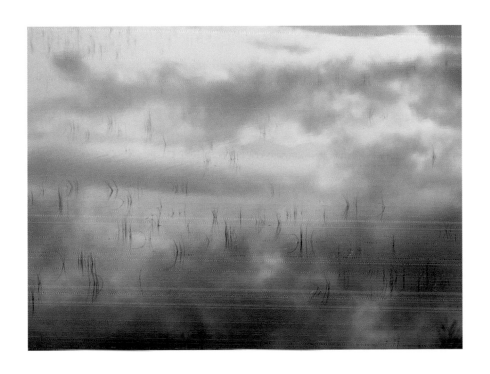

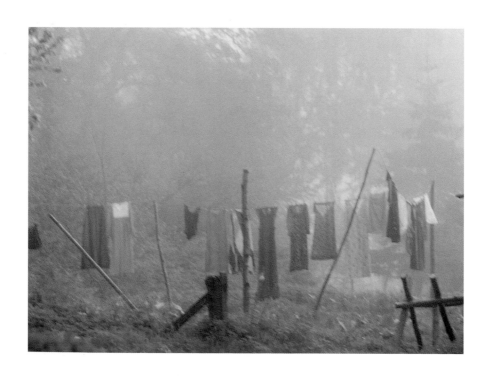

I journeyed on to see more, visiting friends and family members, touching concretely my European heritage along the way. Each place contained a quality of light that impressed itself upon me, from the leaden-low skies of Holland to the painfully brilliant blue reflected off the Mediterranean.

The world was becoming a familiar place. With each physical experience I formed a connection, a bond with the place or the thing or the sensation I felt. I had met a field and it had met me. I had danced with the wind. I had shared strength with a tractor. Seagulls had been my working companions, and a field had sprouted turnips because the earth had collaborated with my seed-casting hands. Hadn't we felt an exchange? For a moment or an hour? Didn't the play of light bind us under the sky?

This reciprocal overture, like people meeting after admiring one another from afar, gave these things an identity in my life and made our interaction a relationship. Not only could I enter and impress my presence on a light-splashed meadow, but it could enter me and tell about its existence as a meadow under the sun. This relationship meant that everywhere there existed a mood, an atmosphere, to be discovered, respected, and shared. My curiosity for these things grew.

There is an experience offered by a landscape lying beneath steely, rain-laden clouds and another offered by the same sweep of land as it emerges from a dawn mist. Was it the actual tactile reality that created the experience or merely the light that surrounded it? I did not, then, understand the subtleties that made those experiences so different, but I opened myself wide to embrace them. The world, in turn, opened up for me. Everywhere I went there was the sky and the earth, always lit at the same time from above and below. Between lay the limitless horizon, vast and mysterious, waiting to meet me.

When the Light Cracked the Horizon

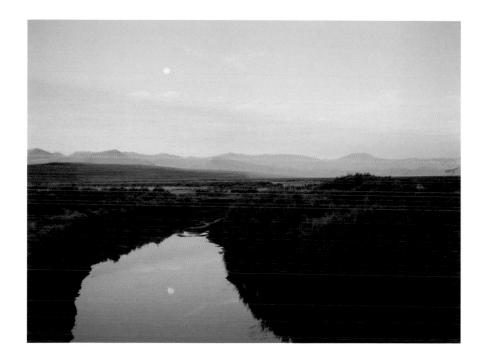

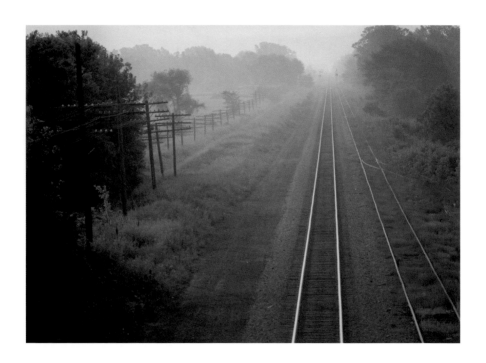

With my discovery of the lighted world came the desire to capture it, to define the illuminated reality, to snatch those most elevated moments when the light itself created the experience.

When we're young, we set out to capture our world in one way or another, with knowledge or perhaps with cunning or even with love. We find our definition of reality and then approach the world in front of us with this guide firmly in hand. It gives us strength and confidence. It makes sense of things.

Light initiated a twinge of understanding within me and so I committed myself to the camera, a light-catching machine. My camera became a ticket to sensation; the images I caught were proof of my being alive and seeing. I was convinced I could seize and immortalize those instances of rapture that I experienced through the viewfinder. This quest for the perfectly illuminated moment, and the ability to take it home with me, sent me to the road.

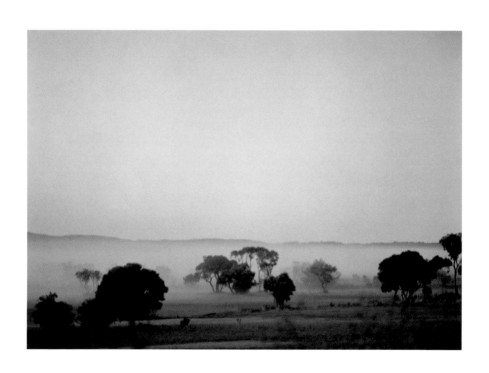

Not wishing to be distracted by companionship, I took to the highway, alone, pulled hypnotically by the broken white line to places where I might experience that belly-full sensation I was hungry for.

Newness was important to me as the familiar quickly grew dull to my young eyes. Urgently, I put many, many miles on my odometer. On the move until night had almost arrived, those last moments of light were often the ones that bored into my sight the most sharply. I would frantically try to photograph the land brushed by the eerie light of dusk, as the sun, in a hurry to escape the coming darkness, would sink below the horizon. I would be left standing by the side of the empty road, a shadow among shadows in an uncapturable twilight.

Sometimes I would drive all night to witness lightlessness turn to dawn. The light flowed like vapor over the horizon and washed the earth in waves of subtle color, each stage igniting another sensation, another emotion. If I happened to be driving eastward, I felt the added intensity of throwing myself into the waves of light, into the flames of sunrise.

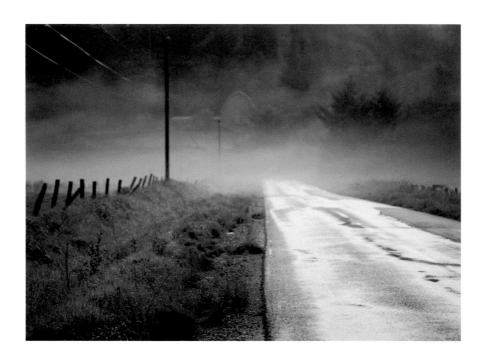

My photography expeditions became races. Each morning, when my eyes would blink open before dawn, my first thought was of the coming light of day. A fear would shiver me. I was afraid I might miss the light, miss the revelation. Miss *the* moment.

As I pulled on cold jeans, my heart would pound, my fingers tremble. And as I sped down a grey damp road, rushing to arrive at the perfect spot in the perfect light, I would fear that I was really traveling in the wrong direction and that the perfect place was behind me somewhere. Or to the east or to the west or over that hill. Panic would creep into the passion and my eyes would search the countryside for a reason to be there at that moment. If I didn't see it there, I would chase the light, a glow in the distance. I'd accelerate down empty roads, only to find when I got there that the light had vanished or moved or changed. Perhaps it was a flickering mirage, or merely a visual desire. I was racing toward a finish line that could be anywhere.

During this period I lived on the coast of Oregon and had the chance to once again spend my days in Nature. I hiked through deep, dark, and dripping forests, always eager for the edge of the wood where the sky would open up and I could walk into the light over cropped spongy turf toward a sea cliff. The stark horizon of the ocean was like a magnet. It had the same appeal as a distance-streaking highway.

One day I wandered to the beach at the end of a chilly, wet winter's afternoon. I stood alone, on a shimmering expanse of low-tide sand. In a spitting, twirling wind I watched the sea and sky shift in harmony from grey to silver to blue to cream to yellow to bronze to pink to mauve to orange and then join together and plunge into darkness.

It was shockingly beautiful. I stood there, listening to the rhythmic pounding of the surf and aching with the inevitable awakening to the knowledge that I could never create something better than the perfection I had just witnessed. I could never capture on film what Nature managed to do effortlessly every day. Trying to snatch or steal these shimmering moments was impossible and pointless. The world's beauty did not need me to imitate or immortalize it. It was already immortal.

This discovery shed light on the puzzling knowledge that although my photographs were pictures of Something, they never seemed to be pictures of what I saw or experienced as I was taking them. Where was my quivering heart, or that damp, warm wind, or the vastness of that evening sky? These were the physical experiences that welded the pictures to my mind. Apparently, Nature shared these with us but wouldn't let us take them.

I thought about this and then concluded, with relief, that I was insignificant. Nothing more than a moment in time, just like a sunset or a single wave lapping upon the shore. One minute in the face of Eternity.

The burden was lifted. It wasn't my job to illuminate the miracles of the world. It had been a youthful presumption. My muscles, taut with the anticipation of having the True Moment revealed to me, relaxed. There was no race. There was no finish line. There was just me, still gripped by a need to record what I saw, but now I relished the equanimity that this identity of nothingness gave me with all living and nonliving things.

The irony of this discovery was that by shedding any greater sense of importance, I also glimpsed a personal identity that (although insignificant) was also as individual and distinct as a snowflake with its own singular, fleeting design.

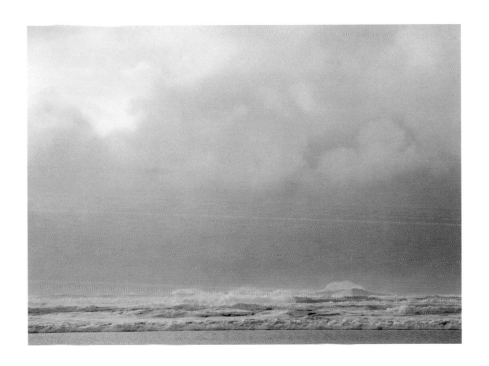

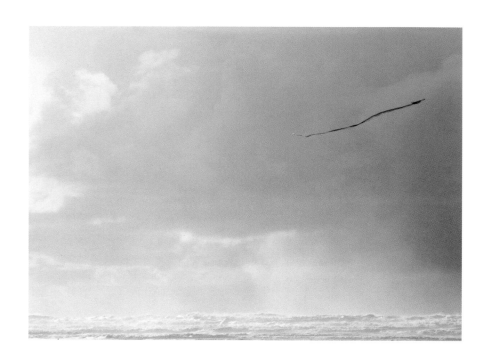

These ideas lightened my load. Anytime I could save a little money from the sale of photographs, I set off alone in search of more pictures, always craving freedom, the space of solitude. Days, sometimes weeks, passed when I spoke to no one but gas station attendants or grocery store clerks in the pausing places along the road. I was drugged by my own concentration, my mind enveloped in silence yet swarming with visions. Endless horizons burned through my eyes and into my soul. I sought the open landscape of the American West, where the weather was different in every corner of a vista and the roads were straight and infinite. Isolated places where isolated people lived.

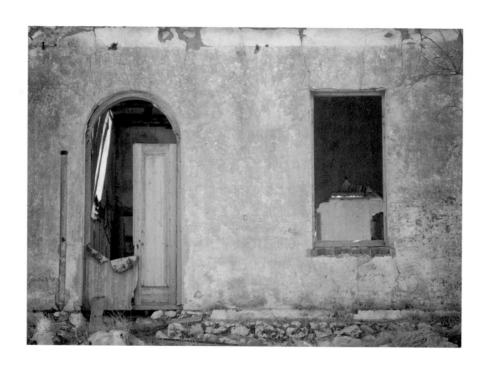

Then Australia called to me with the romance of the Outback and its burning, empty Interior.

With camera equipment in the passenger seat, I drove an old, dusty Ford through nine hundred miles of townless desert to sleep on a wooden veranda that surrounded a corrugated iron house in the middle of a million-acre cattle station. When I awoke, oleander leaves lay on my face and pillow while an apricot horizon pushed away millions of Southern Hemisphere stars in the blackest night sky I'd ever seen.

Under a branding sun, passing over unworn ground, I watched as darkened dusty men worked beneath the black shade of their hat brims. Cattle pens and shearing sheds sprang out of red dirt as flat as a knife blade. A few birds circled high in the sapphire sky. This land stretched for miles and miles, so ancient no stones were left for the scant rains to erode.

At the end of each searing day, the mantle of red dust coating every hair, every inch of skin, and every stitch of clothing, was washed off under the clear gushing unheated water of an open pipe inside a corrugated shower shed. A single yellowy lightbulb overhead dangled on a wire and swayed in a light breath of warm air. As I pushed the door open to let my clean self back into the expanse of the violet evening, there on the ground between rusty puddles, mimicking the night sky, lay a carpet of stars made by the light twinkling through pinholes in the tin walls of the shed. From above, the irregular clanking of the windmill pulled the water from far beneath the parched red soil. And the orchestra of crickets beyond the penumbra of the stationhouse told of the vastness surrounding me.

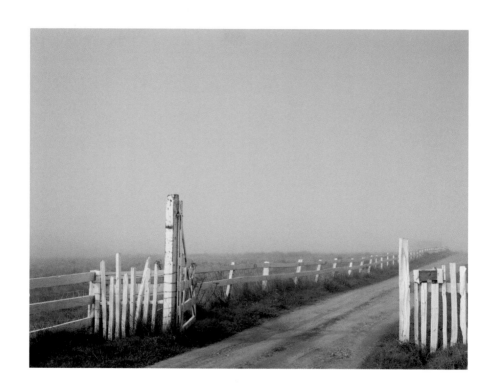

The people were generous, friendly, and tough. They lived their whole lives in this hot, dusty blinding place, and it lived deeply within them. For me they were as much a part of the landscape as the brilliant white ghost gums and the blue-black shadows they cast across the burnt earth.

I didn't stay long enough to lose my observer's status, and with that protection I could be overcome by stimuli without making a personal commitment. My detachment allowed swarming sensations, thoughts, and visions to fill my head. As I drove away from a kerosene lantern-lit breakfast, the kitchen shadowy and blue, the sensation of tight embraces still lingering across my shoulders, the horizon cracked at the end of the arrow-straight dirt road leading away from this place and sent a shot of light at me.

I wondered about the photographs I had taken in this harsh and sensuous place and knew, even before seeing them, that I hadn't captured the things I saw, let alone the greater meaning I so passionately strove for. Instead, I was left with a teeming cauldron of sights and feelings, ideas and conversations, smells, sounds, temperatures, colors and questions swirling around in my head. I was building a bank of memories, a storehouse of uncaptured, silent images, not knowing then that everything I experienced, even if it couldn't be recorded on film, would serve as a reference for the images yet to be found in my future.

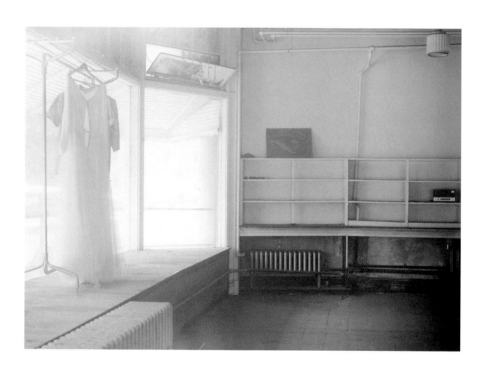

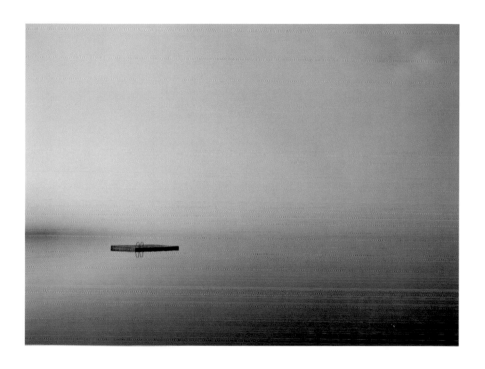

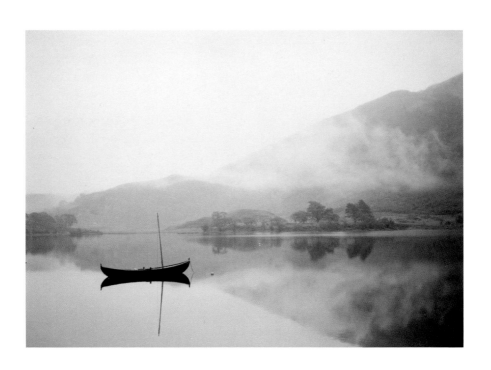

I couldn't capture an eternal moment in a photograph. Of that I was convinced. I couldn't even capture my experiences. So, I began to wonder *what* I was capturing. What was ending up on my film? Misty dawns and vacant windows, lone boats and dapples of light on a wall, a reflection in the water, an abandoned building, empty roads. These weren't universal symbols, nor images of expansiveness. They were pictures of a solitary view of the universe. Working like a prism in reverse, the complex spectrum of life had entered me and emerged as a single and unique beam of light, presenting itself as a distillate of my experience and temperament. These were spare images. Lone places. Disconnected, elusive, silent. Was this the meaning within that insignificant single moment? Was it me that I had captured?

When the Light Lay at the Door

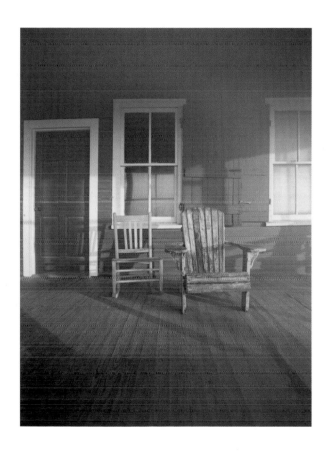

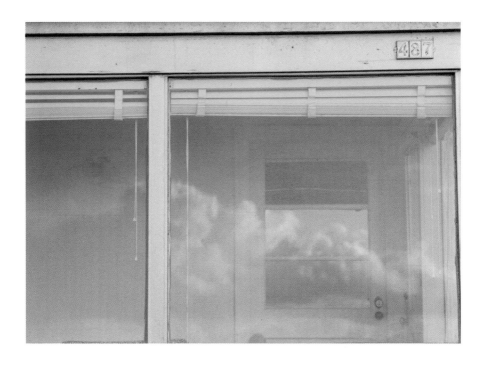

Nature had cradled me with the promise of its ceaselessness. I was more at home with a seagull, or a cloud, or a tree (branches reaching for the light of the sky) than with civilization. I belonged to the living surface of the globe rather than to a place or a person. I was a stone skipping across a reflection, each touchdown propelling me forward but never sinking deeply enough to combine with my surroundings.

It became more and more difficult to maintain my lift in this state of connected separateness. The tug of the corporeal world drew me in. As I recognized my own point of view and it gained importance within the bigger scheme of things, I found myself on a path leading toward an intersection where my hovering phototropic self could meet my human earth-bound identity.

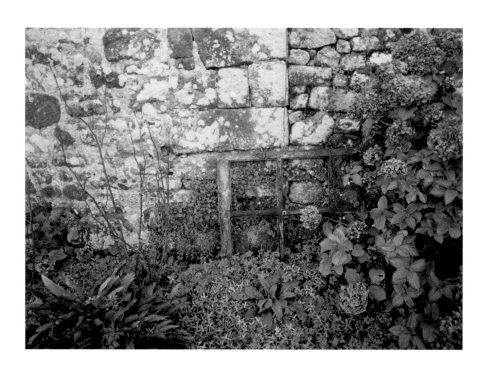

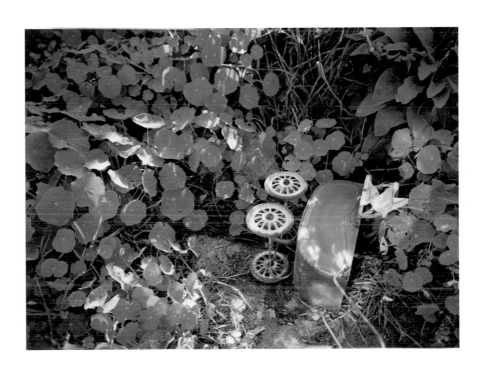

Travel became a necessity, as my photographs became my livelihood. Always on a tight budget and being young, I was invited to stay with friends and family, and friends of friends and family. In return, I cooked meals or weeded gardens, hung out the laundry, and generally tried to disrupt their lives as little as possible. These generous people gave me more than a place to stay in return. Traveling as much as I did, I had no permanent spot to land. So I imagined each abode to be part of a large family, the members of which didn't know each other, with me being the only common link. But the distant horizon, the limitless sky, the hunted light, and now these people and places I held together in an illusionary bond, became too heavy for me to carry alone. Along the fringes of my desire for freedom began a whisper of the idea of Home. The temporal competed for space in my light-built house.

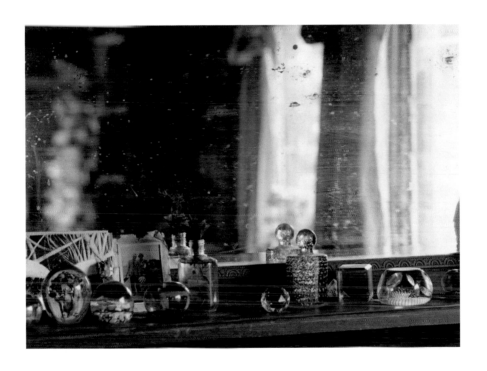

The whisper pried open a crack in my independence and I fell in love. I fell with all the energy that had kept me hurtling toward the horizon. But like all my contacts with people, this one, too, was isolated and detached, contrived by my need to distill every experience to some purer form.

I fell in love with abandon, but also with a vision of love that lived with all the other images in my head. Sadly, this time my visions failed to materialize and find a match in the real world. I failed to connect with one of my own kind. Defining myself by a passion for freedom, adventure, and a devotion to work left little room for comfort, attachment, or another point of view. The limitlessness I lived for was a curse to the permanency I craved.

I was left standing beneath a windswept sky that hovered over an empty, diminished world. What had inspired now saddened me. Each time I turned to the familiar grace of pure light, its intangibility (which, before, left me reeling with wonder) now just reminded me that *intangible* also meant *untouchable* and *unreachable.* From a foundation of experience and memory, the walls of my personality slowly rose around me. I stumbled through a doorway of eclipsed light and resumed my picture-taking with shaded eyes.

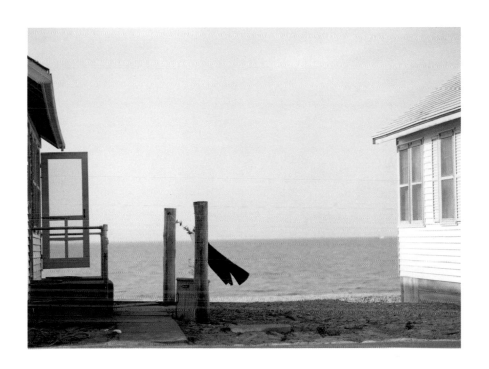

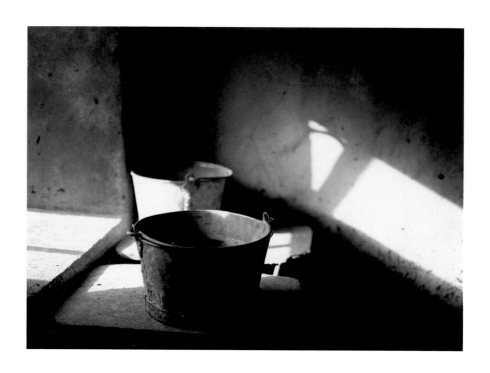

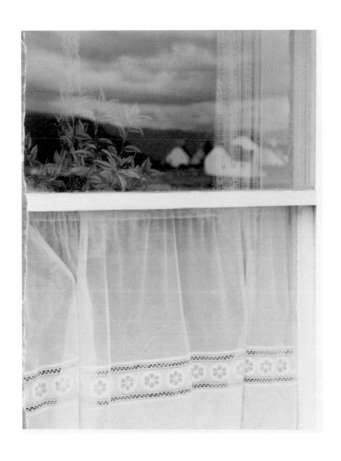

My itch to travel had been subdued by growing doubts in its rewards. However, travel was the only way I knew how to search for anything. It was my means of absorption, like a sponge wiping up a puddle of life in one continuous sweeping motion.

Now distrusting the empty spaces of the desert and prairie, I returned to Europe, where my heritage lay and the roads were cobbled and narrow.

I needed the relief of the finite, to ground myself in the ordinary world where I could hold objects that others had made with their hands. I needed to feel a ceiling over my head. The story of my family, a story of artists and explorers, told me I was part of a tribe with symbols and a language of its own. I found them within myself like a memory I'd inherited but never experienced. Their eyes joined my own and I looked for what connected me to the long procession of humanity that came before me.

Having roofed over my source (the sky) and cobbled the earth (my guide), I had only one place to turn: to the artifacts of humanity. I approached these tentatively, not sure of their rules or whether my previous point of view could transplant into this new place.

So I sought the familiar in confined spaces: the sky reflected in a window or the shadow of a tree on a sun-painted wall. Instead of connecting with the Universe, I tried to connect with some sort of common human experience.

It wasn't the fantastic or the awesome that we shared, it was the simple daily things. The sights on my everyday paths were a deeper source of beauty than any extraordinary place. Soon, everywhere I looked some proof of humanity's moment in eternity captured me. A doorway, a cluttered shed, a rundown porch.

When the light fell, like a wash of truth, every corner that held obscurity also held the potential for beauty.

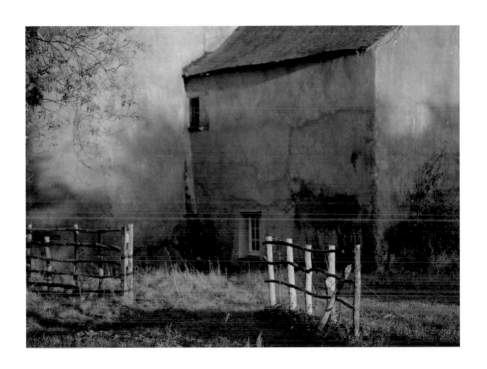

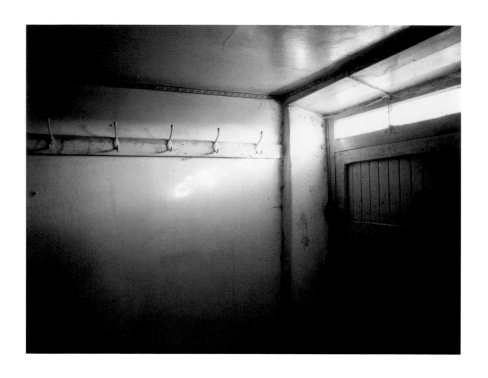

I put aside travel for a time to set up house by myself. While trying to root, my toes scuffing the dirt beneath my feet, I met my life companion. We connected and married. In him I found the guidance and love I had trusted in the earth before. The skipping stone finally slipped beneath the surface and came to rest, rings of harmony radiating from the union.

The need to distance myself from the beckoning horizon had vanished, and I questioned my life as a photographer, a rover. But all I had known was a restless identity. Who was I without the separation that circumscribed for me a clear, untangled, unmingled self?

My husband and I made a home, built a fence around our yard, and planted trees in the garden. The tangibility was increasing. But I couldn't stop traveling; after all, my work demanded it. Yet the trips became more like excursions than explorations, and the search for images lost its most satisfying attribute, that of discovery. It was as if I had seen everything that I was capable of seeing and my eyes were filled up.

Needing another way to define myself, I returned to the land and worked for a while in a nursery potting trees, watering flowers, pruning shrubs, and learning how to grow things—smaller, more delicate things than a field of turnips. I worked with a fever. The work consumed me physically, and each day I came home famished and exhausted. My hands cracked and bled, my muscles swelled, and my back ached. I loved it. My mind was at rest while my body confirmed my mortal existence.

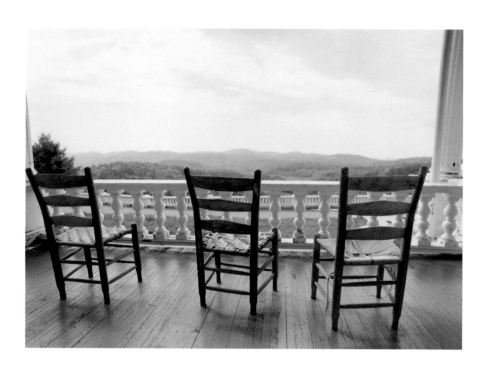

I planted many things in my own garden. Some plants thrived. Others died. And more often than not, the reason for the outcome was a mystery. The cycle of Life and Death, and then Rebirth in the spring, determined the tasks of my days. I became a part of the cycle. My panting breath mingled with the dark living earth and I knew that, one day, it would cease and merge with that same eternally living earth, just as my withered plants had. The garden was a fenced-in cosmos all its own. A place that so perfectly combined Nature and human aspirations. So perfectly thriving on the light that encompassed and defined everything.

One winter morning I arrived at work early, before anyone else. Our first snow had fallen in the night. The air was damp and soft. Everything had been swept clean by the light dusting. The white, muffled silence was nearly complete. Only the scrape of wooden flats against asphalt echoed across the lot as I heaved boxes of plants up from their protection beneath the tables.

I paused, panting. Clouds of breath lingered long and cottony around me. My heat-throbbing cheeks welcomed the slap of frozen air. I stood still and gazed about me: the wet blacktop was blue and pink with the reflected morning sky; the droopy, stalwart pansies had been wilted by the sudden shock of frost; and the sawdust pile, snow-capped like a mountain, was forested with bare, pruned roses waiting for me to bury their shivering dormant roots in pots of warm black soil.

I stood gathering these images around me when something familiar entered the corner of my vision. It was something belonging to me. It entered and then was enclosed in my circle of sensation. It was my husband flying past on the road in his blue van. I raised my hand silently, he raised his in acknowledgment, and in the seconds that it took him to pass I saw myself within my own universe: complete, limitless, lucid and tangled, connected and free. In that moment, lost and then found in a never-ending instant, I moved away from my search for images of experience and began looking for the images I held in my heart.

When the Light Became Memory

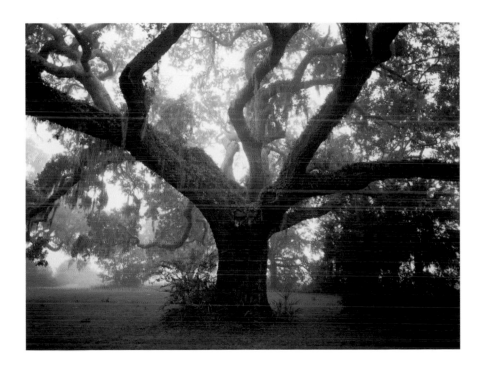

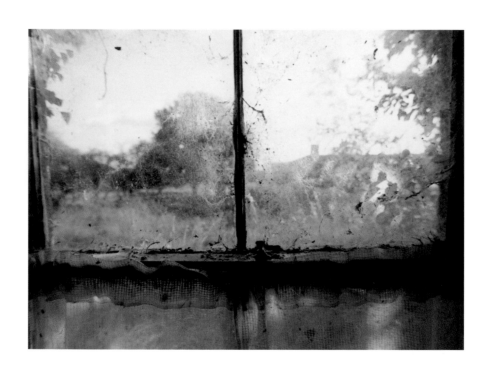

As I entered midlife, I underwent a death of sorts. Most of my inspiration had been based on discovery, on fresh experience, on characteristics of youth. The heap of images gathered in the process was a testament to this, but became irrelevant to my current point of view. It was like a pile of freshly fallen leaves destined to decompose and feed some other hungry life.

I was lost in familiarity. Even though I felt I had come to know myself, my identity was connected with the outside world. It had been a malleable and impressionable entity, altered a little by each new external experience. But now I found my life to be delineated and morphic, subject to the boundaries of my personality as well as those physical boundaries I had chosen. Within them, my old visions—those huge expanses, the single subject surrounded by a freedom of space, even a sunlit façade—seemed like an escapist's album of memories. Faced with my limitations, my mind expanded and was filled with the atmospheres I had encountered along the way, the ether of the actual places. My decomposed youth became the soil into which I could sink my roots and be revived.

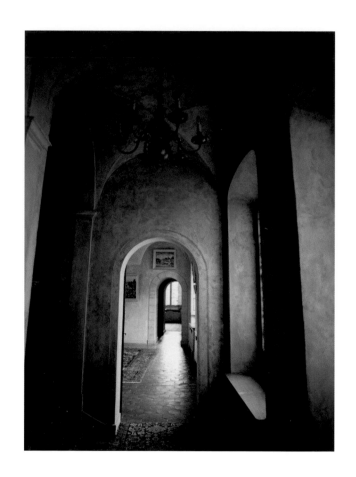

Gradually I withdrew from the nursery occupation that had quite literally bound me to the earth. I returned to my search for pictures.

Years of looking for photographs had left a residue of images lining the inside of my skull. Everything I looked at seeped through a veil of past sights, like beams of light penetrating a series of filters and finally reaching the optic nerve, altered. These inner-pictures weren't photographs I had seen before. They were the pictures I couldn't find, the ones I searched for and never stumbled across and the ones that just sprang out of the confluence of sights that flowed through my life.

Some of the actual photographs I had taken reminded me of these places in my head, but they just weren't the same. They were either missing something or they told too much. So I went looking with a new mission. I was searching for some integrity of spirit, some wholeness, places that traversed time and space that existed without physical definition. This, of course, was impossible to find. How could someone photograph something that had no physical self?

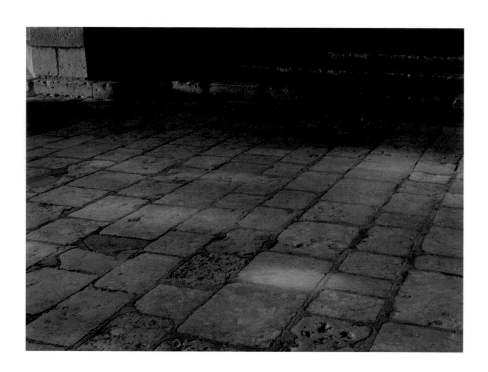

My focus began to shift from outside to inside. The observer's detached view now seemed cowardly and superficial to me. I wanted to get inside, to explore the interior behind the doors, the windows, and the light-struck wall. But what I was looking for had no substantial self, so I became a huntress of atmospheres, sniffing out and recognizing moods regardless of their roles in reality. They could reside anywhere, in anything. I related those hazy, insubstantial images in my mind to places that exuded some similar feeling. Like using a key to unlock a door. It wasn't even pure symbolism I wanted to find. It was the mystery of the way the light lay on a body and created a spirit.

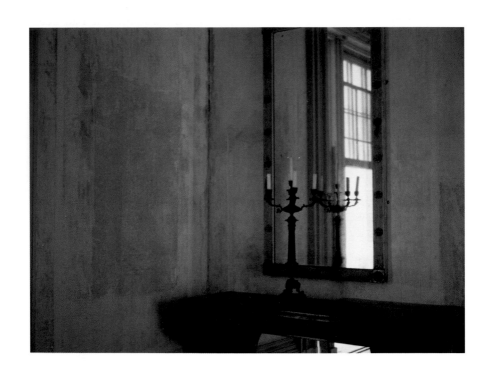

The search was difficult. Even when I finally found that rare combination that, as a photograph, embodied this distillate of feeling, it retained an elusive, subjective character—proof to me that the undefinable had been defined. Like the mind grasping a complicated thought in a moment of clarity, the camera could occasionally trap time and light in a sentient instant before it slipped away.

But often as not the flash is brief. The wink of certainty scurries off to dark unconscious corners of the psyche where it resumes its shadowy existence, leaving one puzzled.

In my search for a way to photograph these moments of understanding, panes of glass resembled the shifting membrane between the inner and outer selves where these mysterious insights reside. Windows in the fixed solidity of a wall allowed light to penetrate the darkness. Rooms reflected the light and bounced it around, a swirling cloud of comprehension. Reality and the atmospheres of my mind met on film, both penetrable and reflective, separating while at the same time transmitting messages, like fingers reaching toward each other in a gesture of understanding.

My camera gave me a very tangible, if not patent, method with which to explore these inexpressible ideas. I embraced the darkness in my light-based world and began a more deliberate investigation of the borderline between my inner and outer selves.

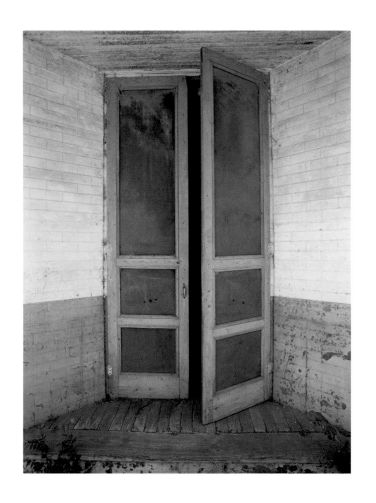

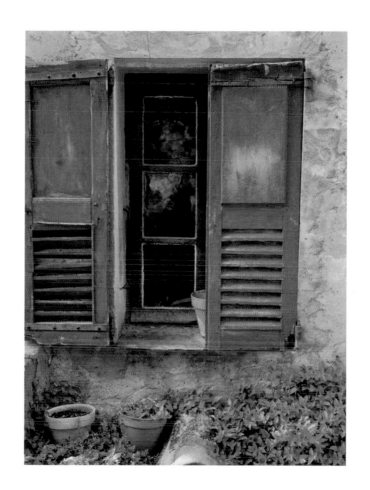

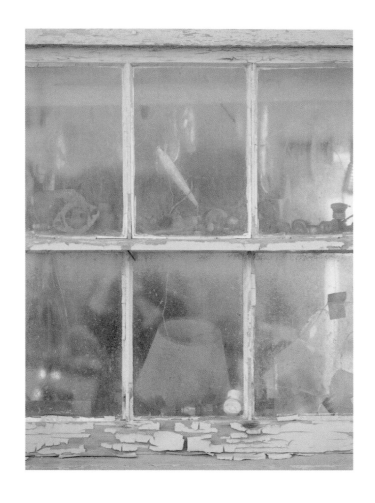

Doors and windows were no longer just members of an image. They filled up the frame. My lens thrust up against their surfaces to examine their portent and then expose the phenomenon. Staircases brimming with choices, ascendance and descendance, promises and direction, were—with their arrangement of repeating surfaces—the definition of the vibration between light and darkness. Rooms with brilliant flash-bulb windows illuminated shadowy interiors. The excitement I felt rivaled that which filled me when I traveled out to meet the horizon when I was younger.

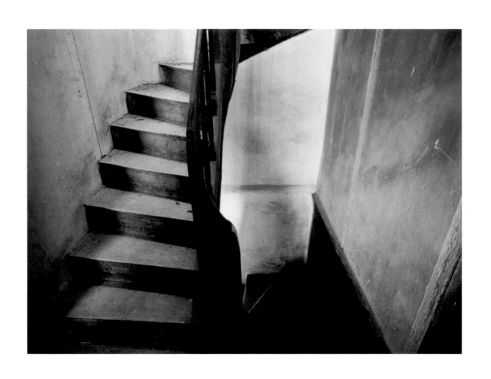

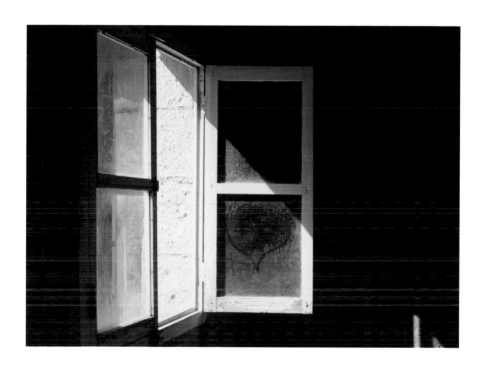

Through the first years of my marriage I continued to travel alone, conducting my quest for pictures in undistracted periods of detachment. But both my husband and I grew weary of unshared experiences and decided that it was time I left the crutch of isolation behind and trust that I would be able to work in his company. We bought a big, old pickup truck and a nineteen-foot trailer, filled them with books, food, maps, our dogs and cat, and from our home in Oregon headed east across the country. We had a vague itinerary that began by crossing the mountains and prairies of the northern states to Minnesota, where we would turn south as the autumn grew colder. It had been many years since my solo long-distance road trips. As the wide horizon-driven days unrolled behind us, I found myself recalling old sensations. The stretch of muscles as we unfolded ourselves from behind the wheel after hours of thrumming confinement. The smell of burnt coffee that hangs around cashier counters at truck stops. The grit clinging to our skin after a day of ear-numbing, open-windowed, pavement-dusted wind. The squint of our eyes. I liked all of this. I recognized that this is what my gut had told me, when I was younger, was freedom.

As a child I had lived in Minnesota until I was eight years old. My family had never returned there, and my husband and I had no plans to stop this time in the city where I'd lived. As we passed through and the freeway took us close to the places I had been as a child but did not remember very clearly, I experienced the strangest feeling. I didn't recognize anything in particular that we passed, but there was something about the light and the shapes of the trees and the grass that grew tall to the edges of the lakes that sent a wave of dizziness through me. The way the land fit to the edge of the sky was so familiar. I had no conscious memories of these things. They were elusive, unlike the clear silent-motion-picture-like events remembered from childhood. It was as if I'd breathed this air before.

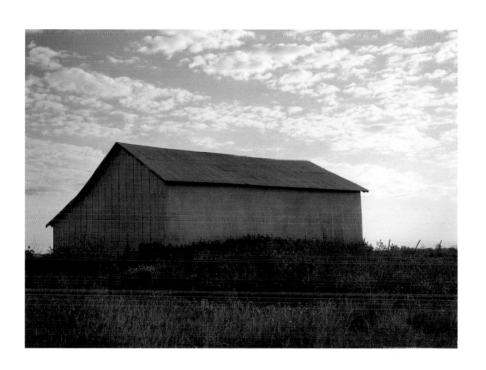

Our easternmost destination was a small island town in South Carolina where my family had lived briefly, twenty-eight years before, when I was nine.

Unlike Minnesota, I had very clear memories of this place. Ever since we left, I had waking dreams about it. In them I would be riding my bicycle, legs spotted with gnat bites, coasting down a sun-dappled, branch-ceilinged street to an oyster-shell bay on the waterway that surrounded our peninsular neighborhood. Or I'd be scrambling over twining, fragrant honeysuckle to sneak into forbidden gardens where the lawns stretched far beyond old wide-porched houses down to the Sound. From a huge oak tree hung an irresistible rope swing. I would catch lightning bugs on humid, buzzing evenings, mesmerized by the green-yellow glow reflected in the cup of my hands.

The daydreams had the salty taste of boiled peanuts bought in little damp paper sacks with the pennies earned from cast-off bottles collected after days of searching the town's hedges and roadsides. With eyes closed I walked to school with a group of children, knowing to turn right here, turn left there, go through the dusty schoolyard to the back door. In an echoey, tall-windowed room, brown and breezy with late summer air, I tucked myself into my desk and waited for Mrs. Sams's heels to sound across the wide wooden floor.

As my husband and I approached the place of these favorite memories, I feared that once I saw the place as it really was, my cherished world would vanish and evaporate like mist heated by the morning sunlight.

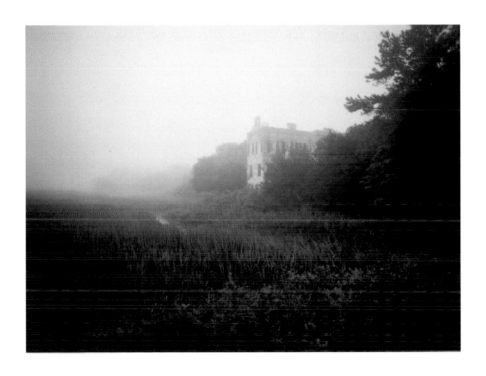

I went to my old neighborhood early in the morning. The coastal area hung in fog. In my nervousness and anticipation I had left our warm bed so early it was virtually dark when I drove into town. Daylight increasing with each turn I made, the streets of my nine-year-old's memory appeared out of the dream.

The buildings that had bordered my memory-sight were all in place. The pharmacy where we had ice-cream sodas, the Lipsitz Department Store, the Methodist Church whose pastel-frocked congregation I watched pour down its wide steps on Sundays while learning to knit endlessly long scarves on a porch across the street. Even my gradeschool was exactly where it had been in my dreams.

Gliding through the streets in a flashback state, I followed my memories' directions and came to the heart of my neighborhood. Huge live oak trees canopied the uneven root-blistered asphalt. Mist hung in them like a cloak, keeping out clarifying daylight until I had explored this illusionary vision.

Each block contained something recognizable. The parting in the vegetation that opened to a white crushed-shell path. The edge of water where I watched porpoises swim by in the Sound. The columned house where my best friend lived. The scarred branches that held our tree-fort. The tangled honeysuckle hedge. And finally the little brick house where my family had slept and cooked and played Monopoly by the whir of a fan on sultry evenings.

But it was more than details. More than pictures in my head.

It was also the smell of the tidal earth. It was the water, lapping against the marshgrass, pale, oily, and serene, stretching out to a faded sky. It was the soft rasping sound of my feet in the gravel as I walked, and the view down the road disappearing into a web of moss tinseled green-black branches. It was the light coming down from the burning mist above, swirling around my head, enfolding me. It was the mystery recalled, and it set my pulse racing in this place emerging before my very eyes out of the gauzy darkness into the light of now.

I had the odd sensation of being inside someone else's body, looking through someone else's eyes.

Had it all started long ago, before my eyes remembered?

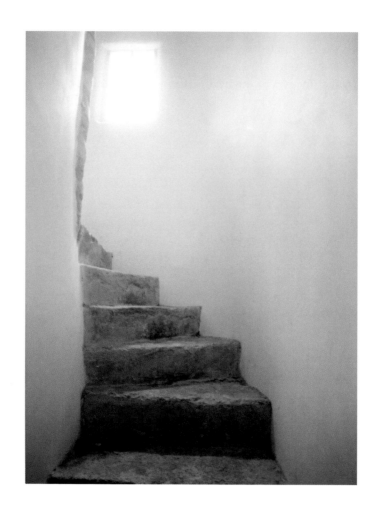

Clearly I have been on a journey since I first opened my eyes. The itinerary has been determined by how I perceived myself and my place in the world.

We are free within the extent of our point of view. We are bound by the limits of our perceptions. Just as each photograph I stopped to take was the key that opened my eyes to the next image, I am convinced that what we see along our path is a reflection, a manifestation, of everything we have seen up until that moment.

Within each of us is a personal treasury of visions, drawing us closer to the unique essence of our individual lives. The expression of our journey changes as each stage unfolds into the next and we see with evolved curiosities. This expression can take almost any form. It can be the way one relates to people. It can be through music, or writing, or raising children, or mathematics, or nature. Anything that makes us feel alive.

There is a natural expansion that takes place as we explore ourselves. It often means learning new languages to express the new insights. We reach outside our self-concepts, are stranded in this no-man's-land, until we find another way to describe this new part of the journey.

My own journey has been defined by light. The camera has been a perfect conveyance for the light I saw outside myself. But as I crossed the horizon into my heart, I pulled all the light I experienced inward and then felt the need to project it back. I wanted, somehow, to describe the light I *felt*, not the light I *saw*—the light which was the source of my experience. It is, for me, the difference between discovery and creation. We each have a source inside which grows by living our lives, yet—at the same time—this source is the origin of our life's map. It is the mystery within us. It is the wellspring of our personal chronicle and the secret code that guides us.

≈ ≈ ≈

List of Photographs

Cover Photo - *Kirsty's Drive* (Western Australia, 1982)

Page 3 - *Dawn on the Willamette* (Oregon, 1980)

Page 4 - *Topaz and Peridot* (England, 1981)

Page 6 - *The Place* (England, 1986)

Page 9 - *The Sky Spilled Over* (Scotland, 1984)

Page 10 - *How to Save Your Wellingtons* (Scotland, 1981)

Page 12 - *Inverness* (Scotland, 1978)

Page 14 - *Birch Branches in Winter Are Pink* (England, 1981)

Page 16 - *Beech Avenue* (Scotland, 1978)

Page 17 - *Reapings by the Sea* (Scotland, 1981)

Page 19 - *Stitches in Satin* (Scotland, 1984)

Page 20 - *The Thompson's Clothesline* (Scotland, 1978)

Page 23 - *Luna* (Oregon, 1980)

Page 24 - *Morning Headed North* (Indiana, 1981)

Page 26 - *Morning Eyes* (Western Australia, 1982)

Page 28 - *Picking up the Mail* (Oregon, 1982)

Page 31 - *Waves* (Oregon, 1982)

Page 32 - *Hovering Incidentally* (Oregon, 1982)

Page 34 - *Muted Ruins* (Western Australia, 1982)

Page 36 - *The White Gate* (California, 1985)

Page 38 - *Promised* (West Virginia, 1981)

Page 39 - *Composed* (Washington, 1986)

Page 40 - *Legend and Lore* (Scotland, 1984)

Page 43 - *American Repose* (South Carolina, 1993)

Page 44 - *Instead of Blinds* (Oregon, 1982)

Page 46 - *The Place behind the Wall* (France, 1987)

Page 47 - *Cast Away in the Nasturtiums* (Western Australia, 1983)

All of Deborah DeWit Marchant's photographs are full-frame, unfiltered, and unmanipulated.

About the Author

Deborah DeWit Marchant is a self-taught photographer, painter, and writer. She has been exhibiting her work in galleries in the Northwest for more than twenty years, and her images have been used on the covers of books and magazines, and in calendars. She lives and works with her husband, three cats, and fifteen pigeons (to date) in a suburb of Portland, Oregon. This is her first book.